ALFRED WALLIS
COLOURING BOOK

Unicorn Press

Unicorn Press Ltd
66 Charlotte street
London
WT1 4QW
www.unicornpress.org

Published by Unicorn Press Ltd 2015

ISBN - 978-1-910065-80-8

Cover, insides and illustrations designed by Liam w
Printed in

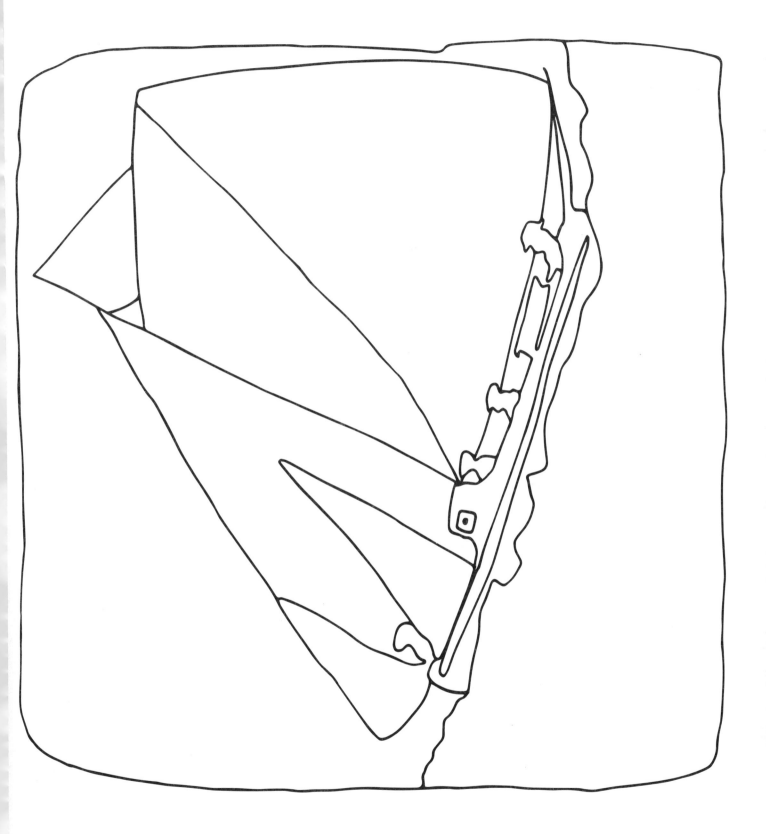

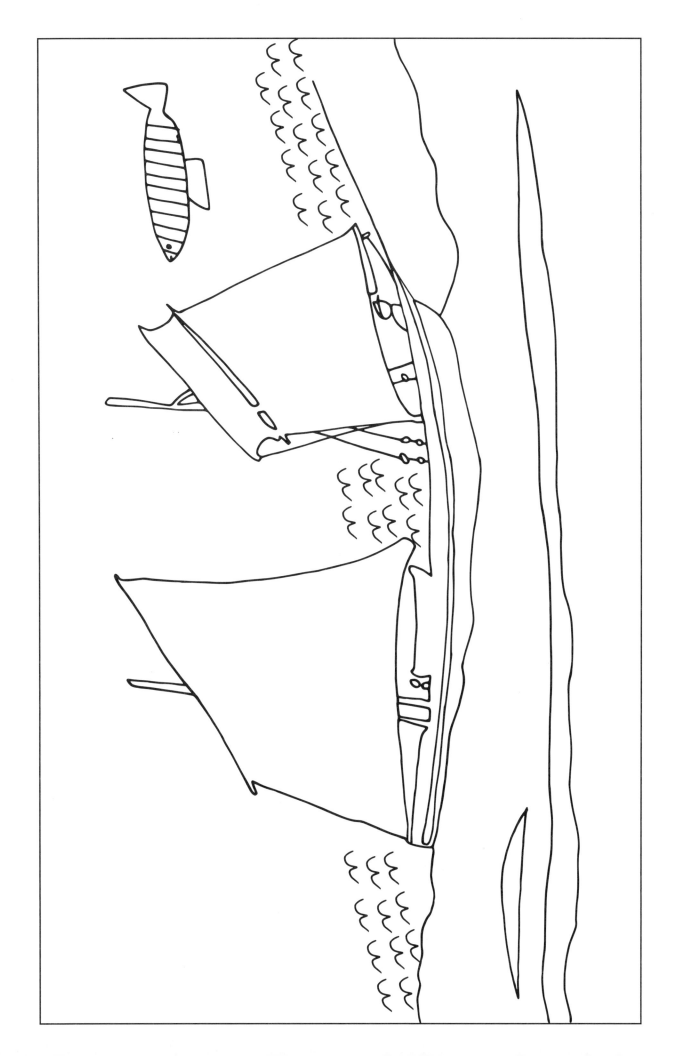

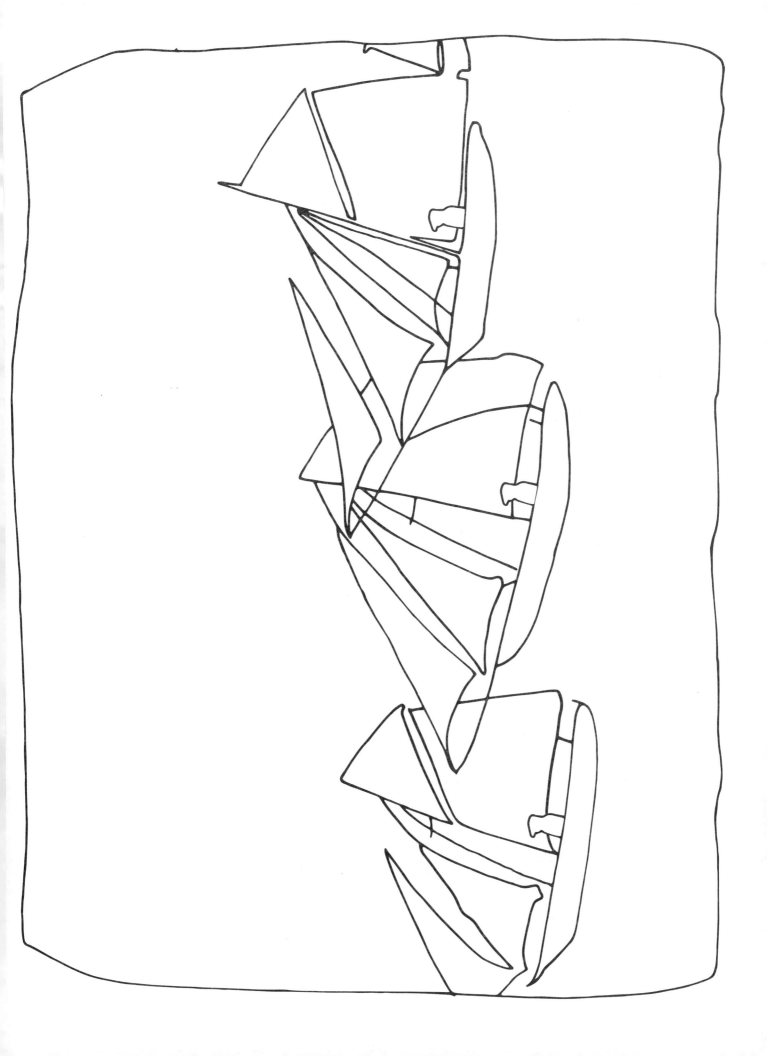

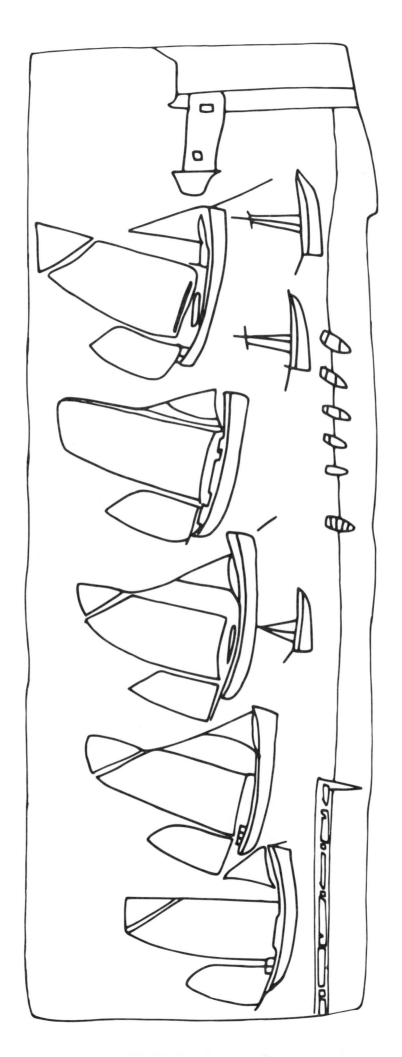

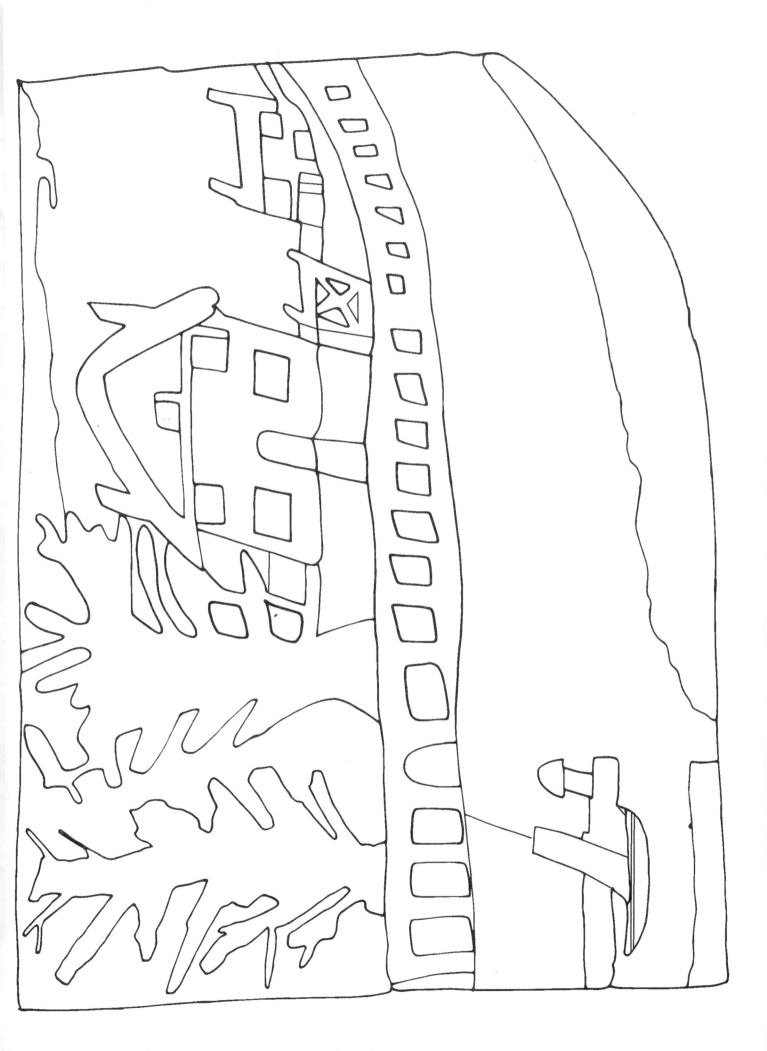

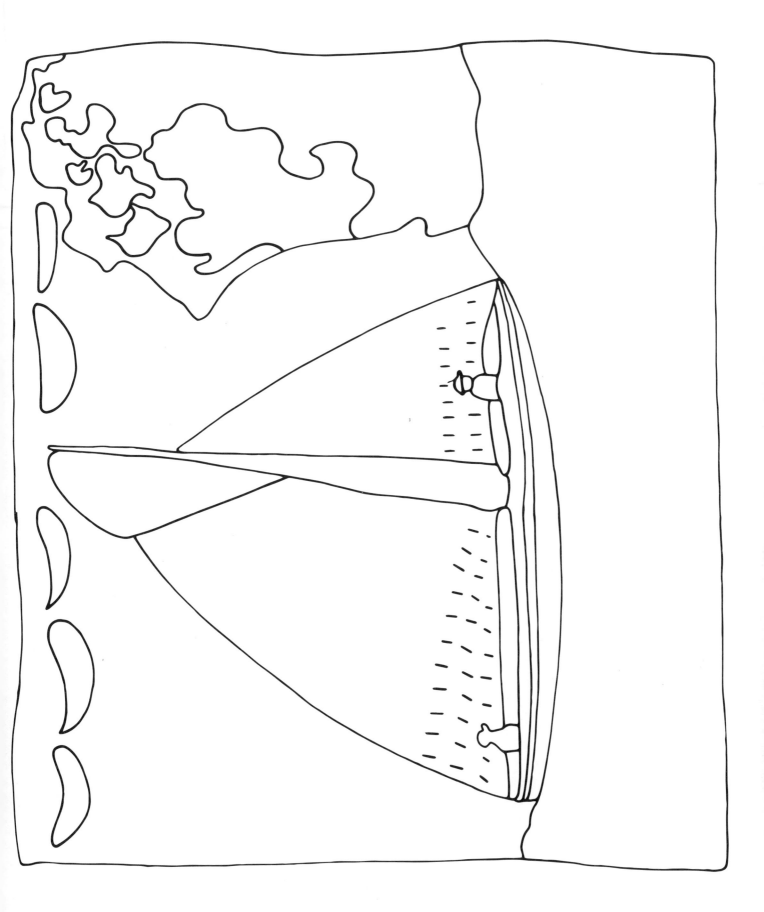

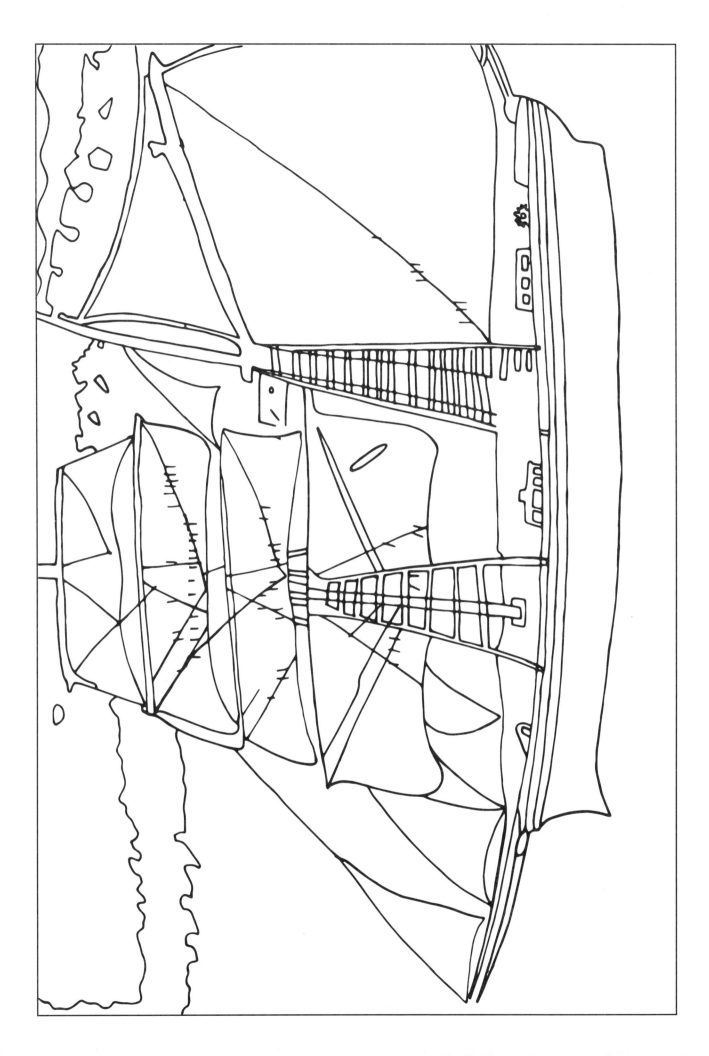

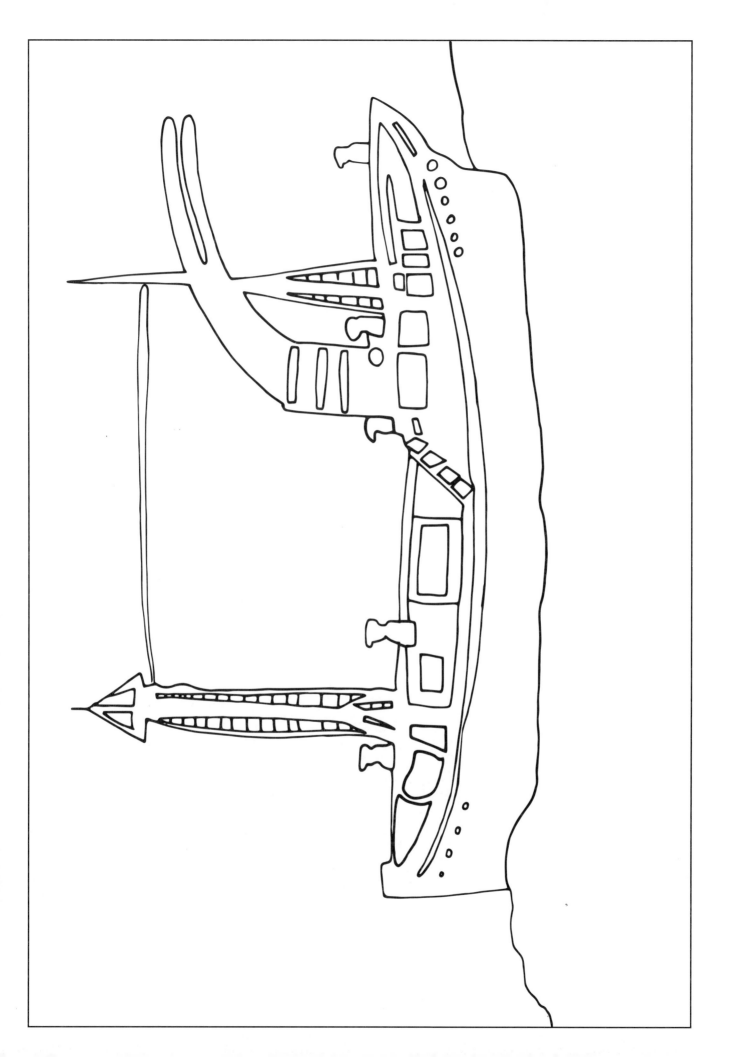

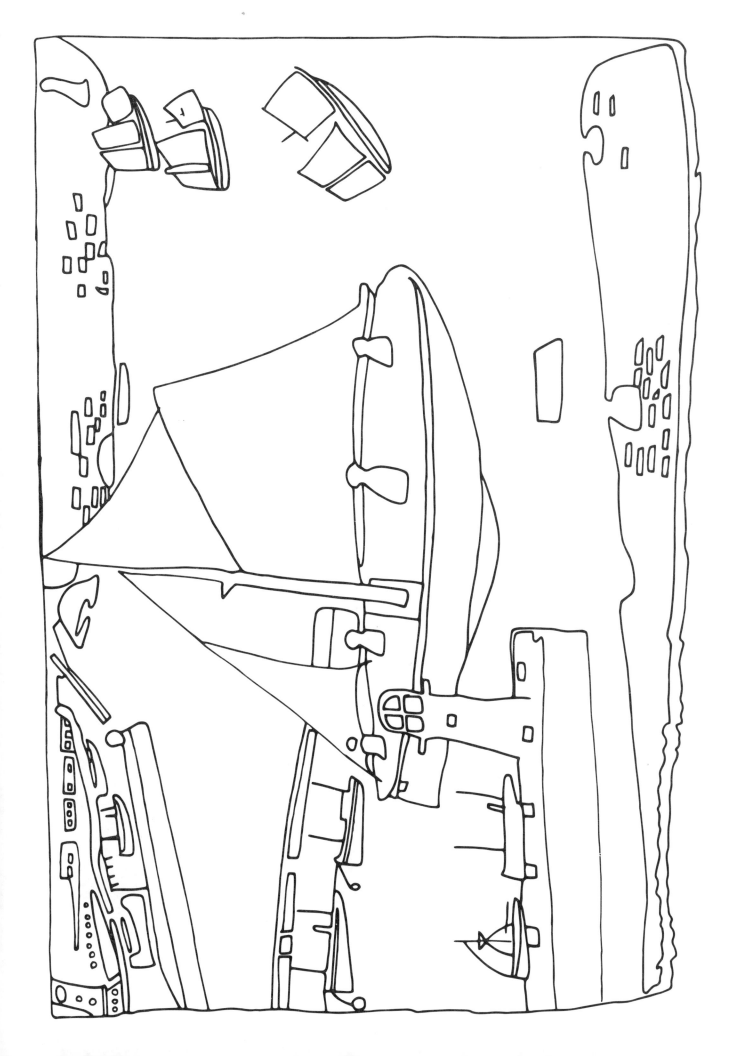

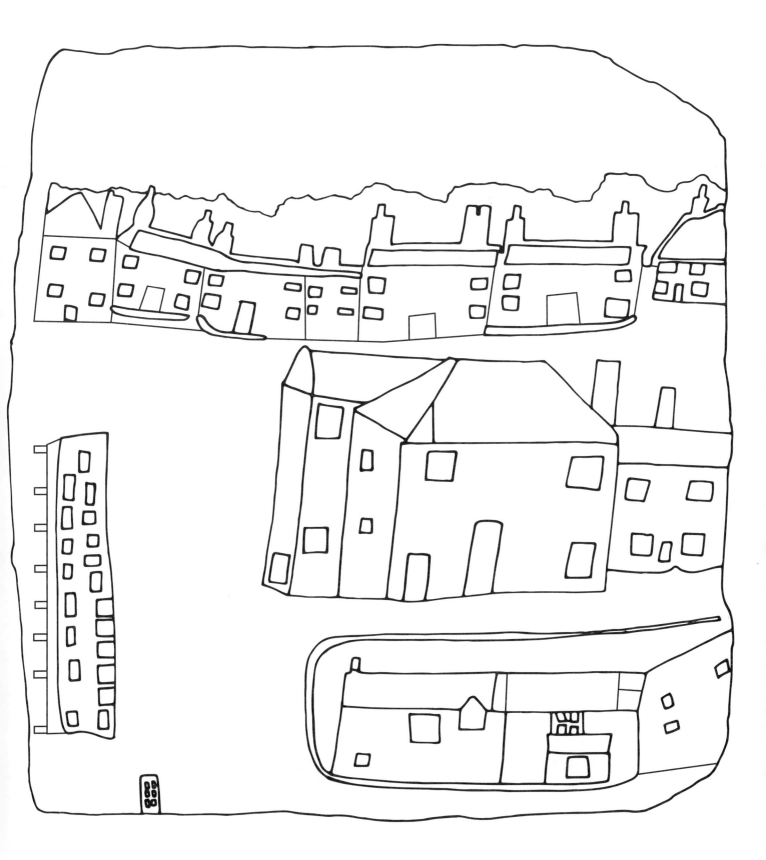

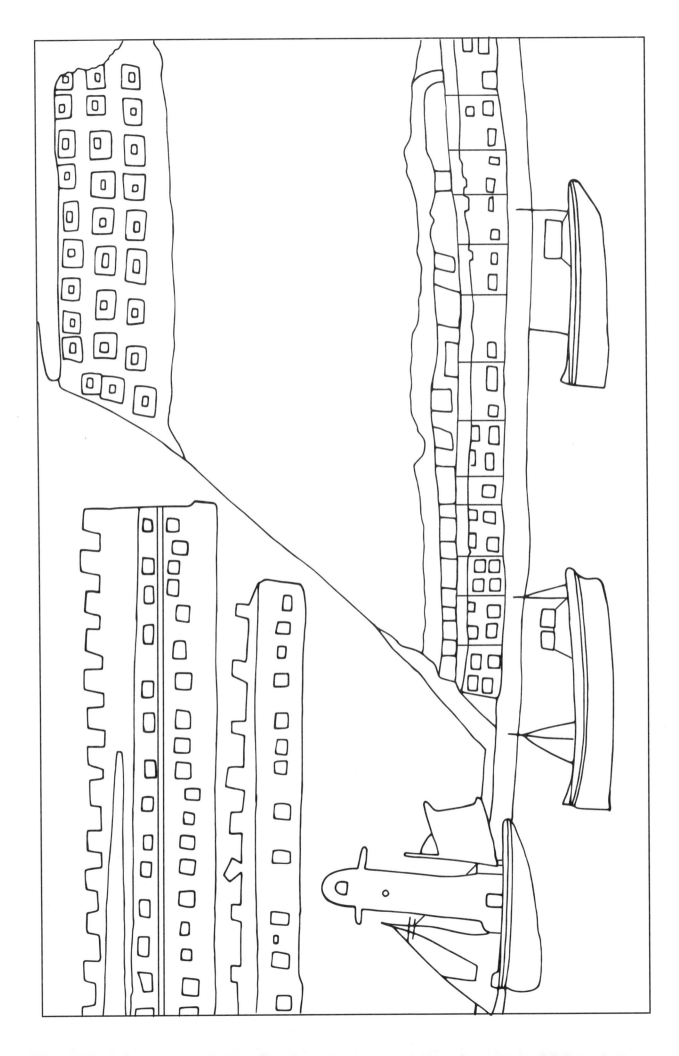

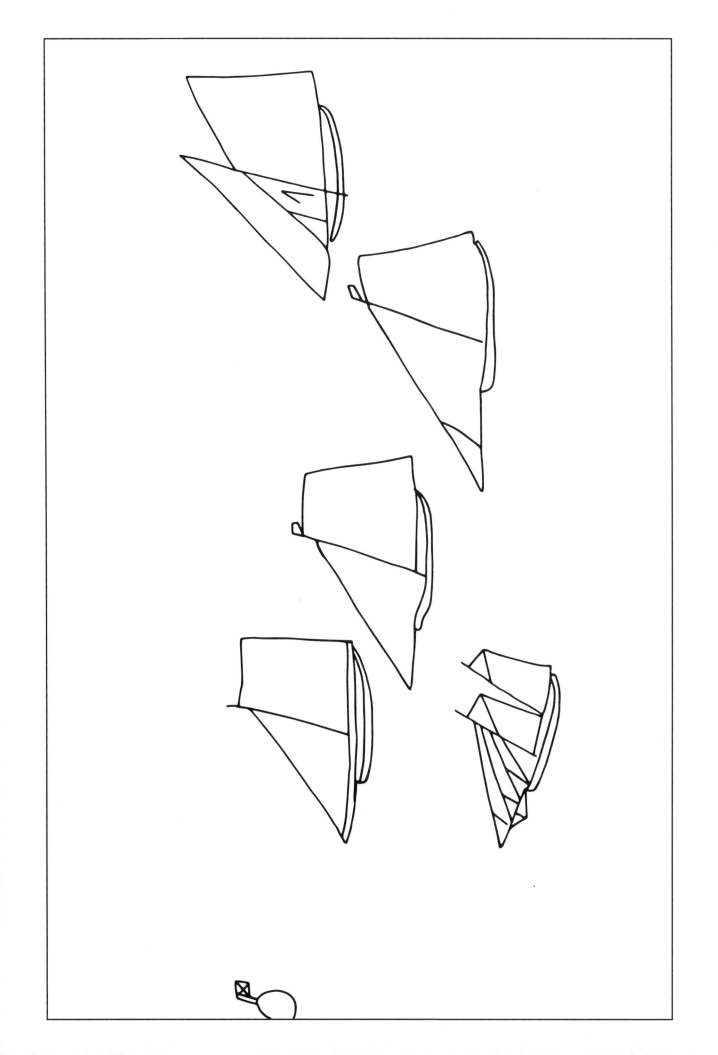

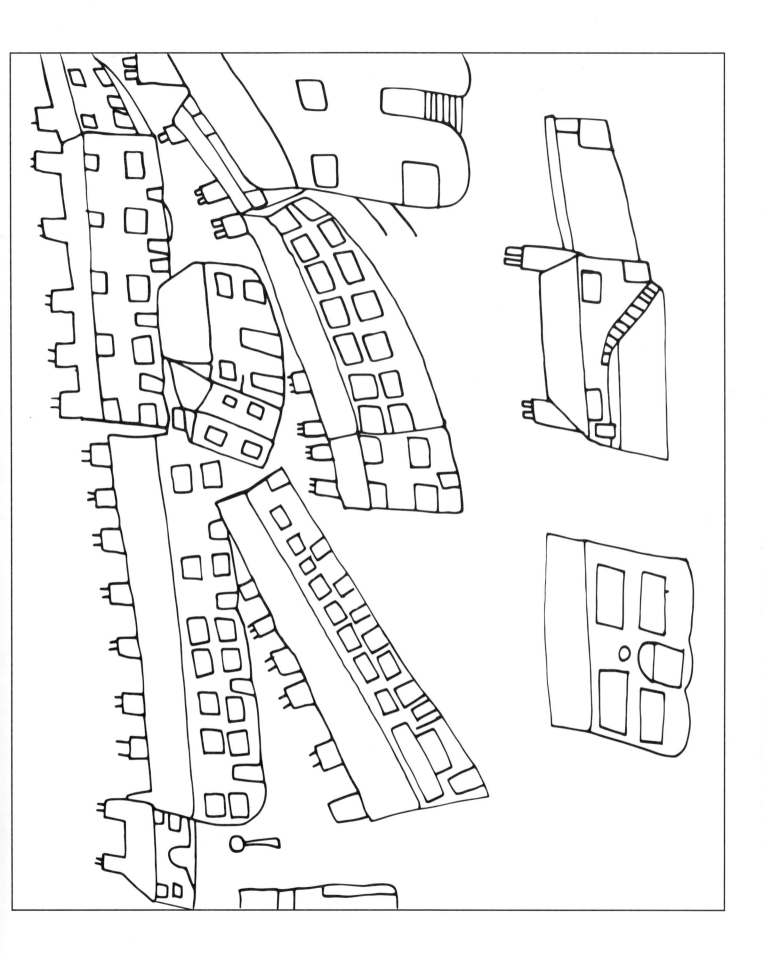

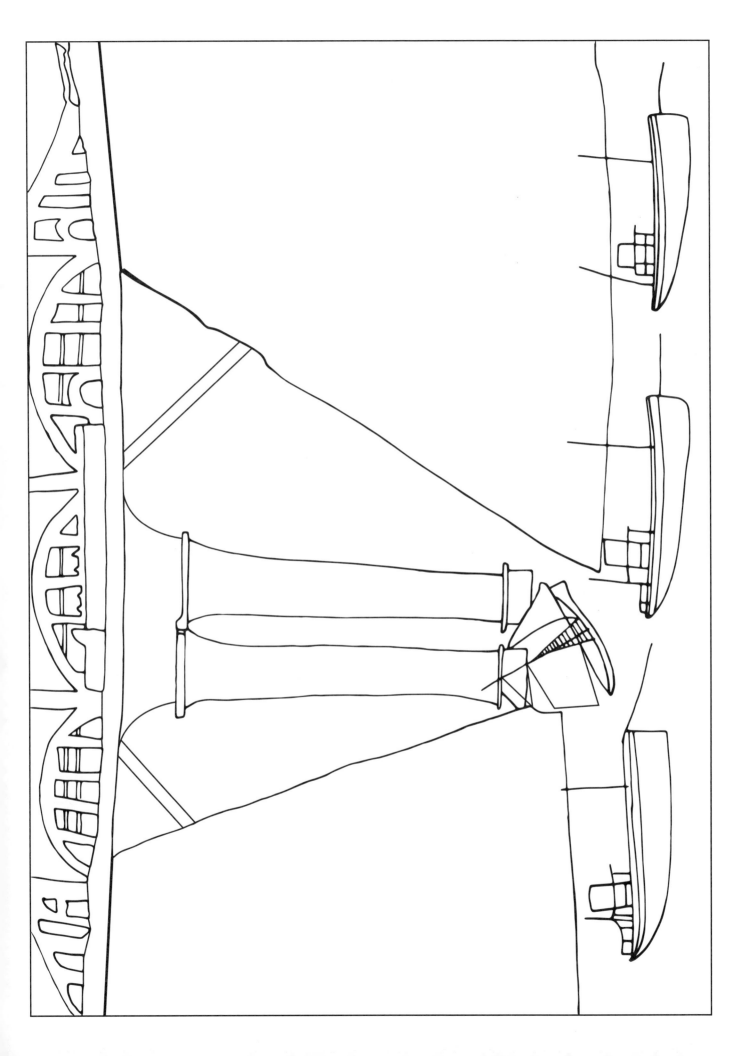

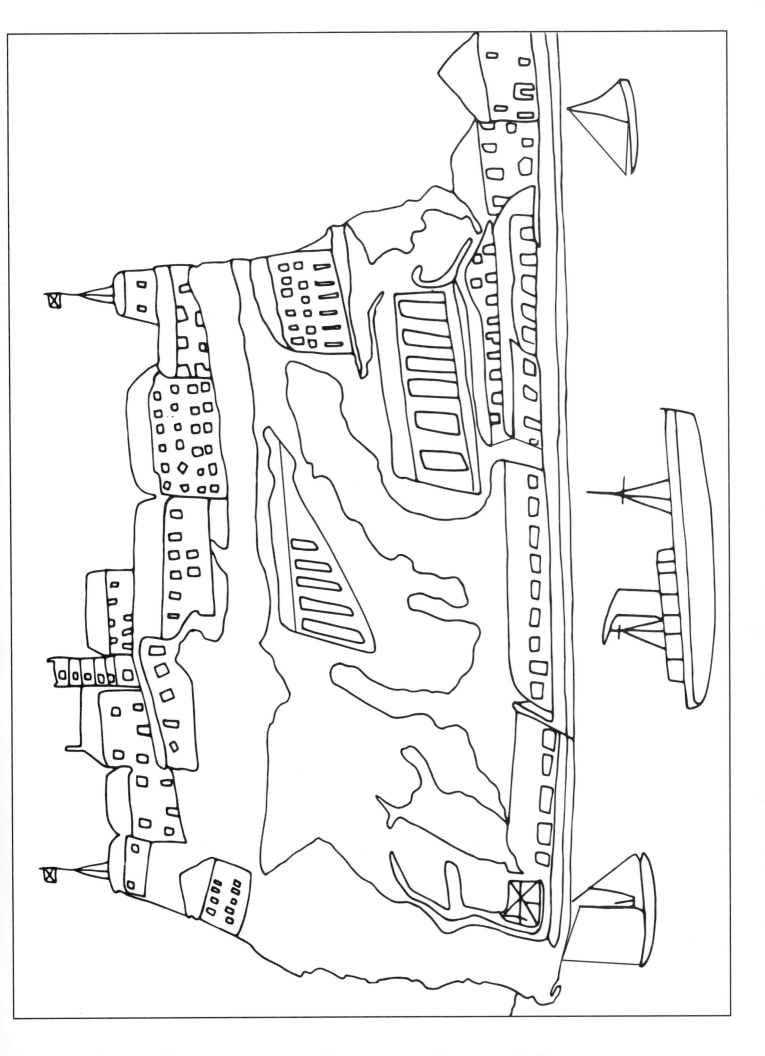

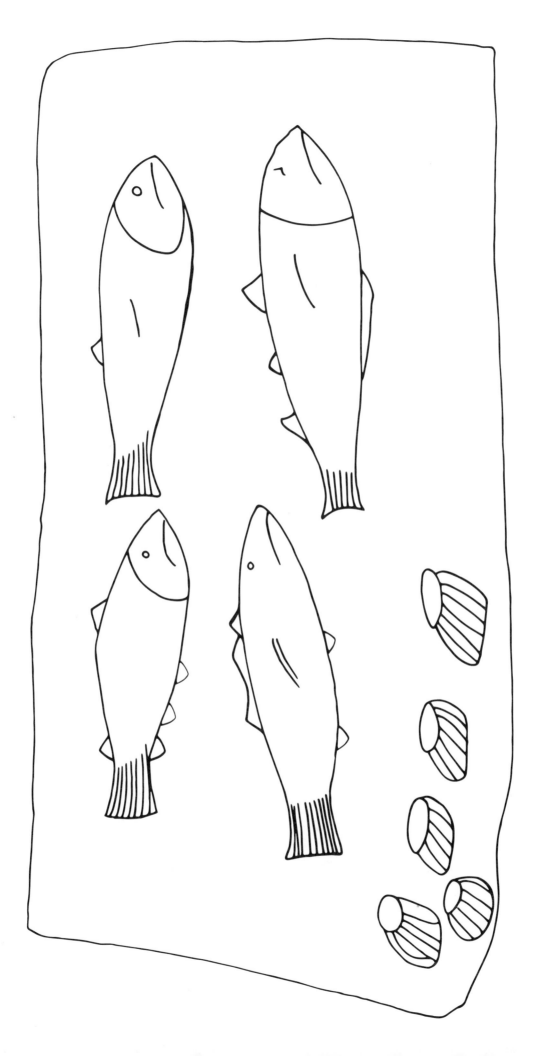

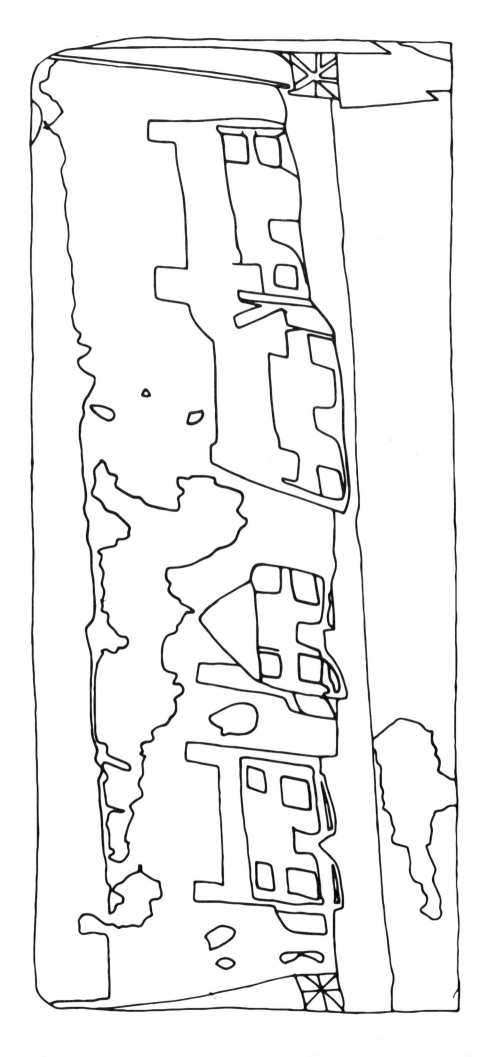

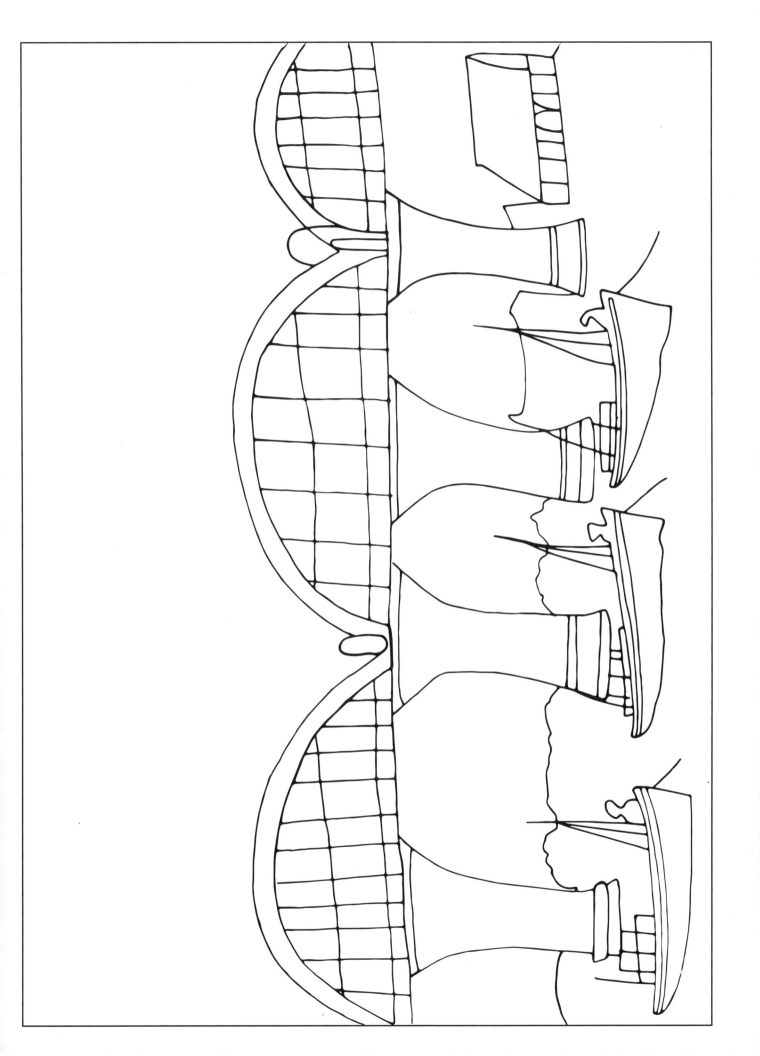

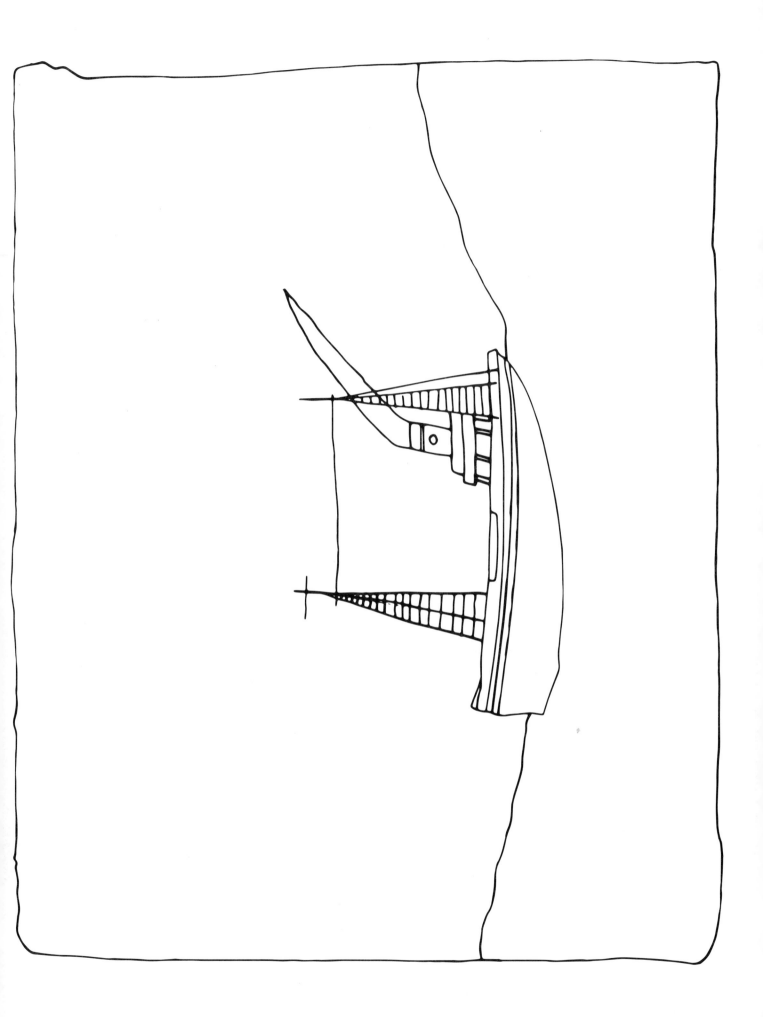